solstiss

The seduction of lace

© 2006 Assouline Publishing
601 West 26th Street, 18th floor
New York, NY 10001, USA
Tel.: 212 989-6810 Fax: 212 647-0005
www.assouline.com

Translated from the French by Molly Stevens, The Art of Translation
Captions by Perrine Scherrer and Camille Dumat

Color separation by Gravor (Switzerland)
Printed by Grafiche Milani (Italy)

ISBN: 2 84323 9486

No part of this book may be
reproduced in any form without
prior permission from the publisher.

ANNE KRAATZ

solstiss

The seduction of lace

ASSOULINE

You can never be too modern, Gabrielle "Coco" Chanel once said. And what better example of modernity than Cecil Beaton's 1936 portrait of the legendary designer posing in a gold-lace embroidered dress, gilt with sequins. In this iconic photograph, Mademoiselle Chanel, known for borrowing from menswear and offering women a new way to dress, stands with her arms crossed over her bosom, challenging the femininity of her own design. But while she set out to defy, her attempt failed because lace, in and of itself, is feminine.

"If what you want is to be modern all the time, you run the risk of one day going out of fashion," Oscar Wilde used to say. But Karl Lagerfeld, the mastermind of the house of Chanel today, and bona fide connoisseur of reinventing the past, has proved

Anna Mouglalis in a Solstiss golden lace dress for Chanel; photography by Karl Lagerfeld.
© Karl Lagerfeld/Chanel.

otherwise. What may once have been considered modern, in fact, never goes out of style. In 1996, Lagerfeld designed a lace sheath with gold sequins for his summer collection. Introduced sixty years after Gabrielle Chanel's golden dress, Lagerfeld's lace creation was more modern than ever. Herein precisely lies its unrivaled uniqueness. Pompadour pink and blue satin, Renaissance green and dark red velvet, Romantic-era taffeta, 1950s seersucker with little flowers, can all become tired —quickly. Once a fashion enthusiast recovers from everything else, he or she returns to lace, which is so universally loved.

Lace bears an important message. Ask any man what the word evokes, and he'll say, "Lace is black. I'm launched into the galaxy of Planet Eros." The majority of women will answer, "Lace is white. It paves my way into the frost-covered forests of platonic love." This unusual duality, this automatic contrast of reactions—and yet the duality doesn't exist because it's interwoven—demonstrates the role lace plays in the collective imagination. But there is one thing everyone agrees on, whether lace is black, white, or another color: Lace is about love and desire. For it complies with the skin it dons and allows its open spaces to be filled with flesh. That is why making lace is a unique profession that can't be performed by just anyone.

O f course, handmade lace came before the machine-made kind. Lace products were among the most skilled and inspiring of handicrafts. A certain amount of courage and a lot of dexterity is needed to instill the luxuriousness, to arouse the wonder, to create the miracle that is lace. Four lacemaking families from Caudry, in northern France,

have had this courage and skill for more than a hundred years. In 1974, at a time when the lace industry had to adapt to a fashion world that rendered the secular criteria of conventional femininity obsolete, these lacemakers gave new life and breadth to their age-old talent by creating a unified company they called Solstiss.

Very quickly, the quality of Solstiss lace and the range and originality of their models, which were designed in-house or by designers working on particular projects, turned the company into the top lace producer in haute couture and luxury prêt-à-porter. Solstiss attained these heights because the men and women who formed the company undoubtedly understood that the tradition of their profession was something that could endlessly serve new creative endeavors. The tradition of machine-made lace is in fact fed by the much older handmade one, which also provides aesthetic inspiration. Handmade lace enjoys a technical freedom: Threads can be crossed and knotted and placed in front, in back, on top of, or next to each other. The lacemaker therefore has myriad possibilities with which to convey the nuances of a design. This is much more difficult to accomplish with a machine, since the threads are moved at once, in a back-and-forth movement that progresses from bottom to top; it is impossible to go backwards.

Lace is unique. The mechanical loom had to be very specific, different from the one used in weaving professions, even if certain processes developed by Joseph Marie Jacquard, a French silk weaver and inventor, could be incorporated. The lace loom was invented by an Englishman, John Heathcoat, in 1804. It was brought to Calais, where it was first used to make tulle. The Heathcoat technique was original in that it wound the loom thread around a bobbin, which was then placed inside a shuttle

that moved from front to back. Because making the finest possible tulle was the goal, the bobbins and shuttles were constructed from extremely thin metal. Their use required as much skill as did making the lace itself.

Because of the intelligent design of these looms, the shape and size of the bobbins and shuttles have remained essentially the same since the early nineteenth century, even though the manufacturing process has been continually perfected, notably by French tulle workers. Nevertheless, it seems that today the best lace is made only on Leaver looms, invented by the English Leaver family.

Solstiss uses Leaver looms for its high-end line. The lace they produce is not only extremely fine and light, but its pattern, whether floral, geometric, or abstract, pops out neatly from the background. Leaver loom lace is clearer than lace made on other looms, which "knits" the lace in a zigzag pattern. While other kinds of looms may be faster, this speed can result in a difficulty in distinguishing the base design from the motif. And, an essential element in lace is precisely a contrast between the background—whose mesh can vary or be regular—and the motif.

Let us return for a moment to the invention of lace. It happened at the beginning of the sixteenth century, relatively late in the long history of textiles. But it was no coincidence. It was the beginning of the Renaissance, a period characterized by the rejuvenation of European thought and aesthetics. Everything seemed possible in terms of both conception and skill. Transparency, in particular, was until then thought

to be only about softening the visible. It held little interest during the Middle Ages, when the primary concern of the populace was covering the body, not uncovering it. But during the Renaissance, transparency became a pressing need in fashion. Lacemakers, who were coming out of embroidery workshops, had the groundbreaking idea of making transparency in one whole piece, by creating empty spaces around solid ones, which were in fact also empty. At the risk of sounding trivial, lace can be compared to a spider's web. There's always an organic dimension to lace that is both natural—it exists in nature—and wondrous. (A spider's work, which we all noticed as children, remains mysterious).

Once the basic concept of lace was developed—creating empty spaces around a chosen contour—it immediately became a luxury item. There is no wonder why it was coveted by the fashion-conscious.

As with all luxury goods, this lust was not only related to the extreme difficulty of making lace, to the fineness of its threads or to its high price. It wasn't even a matter of the beauty of its designs, which were first kaleidoscopically geometric and then nature-oriented. More than anything, its appeal had to do with what makes lace unique: it flatters, dramatizes, and mythologizes the human body. Women of all ages, from every class, young men in shining armor, old men with flowing beards, could be seen wearing huge ruffs, offering their faces on a platter made of three or four rows of starched lace. In the princely courts, you couldn't be seen without it.

Then came the period when dandies—young, slender men—had long hair pouring over large, flat, and scalloped lace collars as seen in Van Dyck's paintings. Colbert and Louis XIV wore cuffs made of a Venetian needle lace known as Gros Point de Venise.

The designs were so pronounced that an English sculptor once made a wood imitation that was worn to a court ball.

The seventeenth century was the quintessential era of French elegance. Men wore only jabot ruffles and cuffs, made from the same lace worn by women: Binches Point de Neige needlepoint lace, Malines lace with clover motifs and bourdon stitching, Brussels lace with a heavy, open-petal pattern, Alençon lace with its intricate design work and light weight, and finally Argentan lace with its flower baskets and "partridge eye" background of small hexagons resembling the shape of France itself. Silk Chantilly lace—with its sumptuous flower background—was the supreme lace of the nineteenth century and was used for crinolines that stiffly displayed black bouquets of flowers. This was a time that belonged to women—and lace was their exclusive domain.

Lace was feminine at its very core. Men adopted it at first as well, as a means of expressing their feminine sides. It was also during those years that weddings became occasions to wrap women like luxurious packages to be delivered to their male recipients. The bride would approach, glowing in tulle, haloed in gauze, angelic and virginal. (The celestial metaphor is part and parcel to white lace.) On the other side of the spectrum was black lace, worn by the repentant and the widowed, donning mantillas during large masses at the Vatican.

The first machine-made reproductions of these veils and shawls were so convincing that it became difficult to differentiate the new lace worn by bourgeoise from the lace heirlooms sported by the aristocracy. When Tolstoy's heroine Anna Karenina approaches her death wearing a blue velvet dress with white lace, two "small hands" watch her from a hiding place and wonder not about her suicidal determination but about whether

her lace is machine or handmade, showing just how successful the machine versions were.

For everything feminine evokes illusion, mystery, confusion, and emotion just as lace does. And lace never fails to offer what no artifice can guarantee: beauty in what is most fleeting, and therefore more desirable. Through lace, we constantly have a sense of possibility, because the possibility cannot be grasped. Shadow and light stage theatrical and elaborate scenes. The rhymes of lace's language are both incomprehensible and familiar.

Solstiss has entirely succeeded in integrating this most important paradox into its production. It is no coincidence that the greatest fashion designers—who are able to seize the fundamental ambiguity of beauty better than anyone else for their own use—have all chosen to dress the dreams they offer their clients in Solstiss lace. Creativity is one of the strengths of the house, which introduces 450 new models in a wide range of colors every year. The chromatic output has also helped attract a younger clientele. The way in which lace has been adopted by all generations is, in fact, one of the most interesting phenomena in fashion, for it is emblematic of a general penchant toward one of the symbols most commonly associated with lace: that of elusive femininity, as opposed to sexuality offered without mystery.

It's because they believed in the enduring power of allusive transparency that the Solstiss lacemakers clung to the dream of surviving a time when Courrèges reigned or when, in the 1970s, new rules of desire seemed to favor sterile nudity, void of

mystery and joy. In 1983, however, a major exhibition entitled Fashion in Lace at the Palais Galliera (Musée de la Mode et du Costume de la Ville de Paris) was organized. Alongside lace made by the French royal workshop and by Venetian or Flemish ateliers, designer dresses from the 1930s to the 1980s were on view. There were couture dresses by Jacques Fath, Pierre Balmain, Rochas, Lanvin, Balenciaga, Christian Dior, and Patou/Christian Lacroix, and there were dresses made with Solstiss lace by the rising stars of haute couture of the time.

The showing demonstrated that evening events have always included lace, even at a time when blue jeans were invading everyone's work wardrobe without discrimination. In terms of the number of visitors, this exhibition was one of the biggest successes that the Palais Galliera has had. It was followed by other major shows organized by Solstiss that have proved an undying love for lace. They included Lace Body at the Carrousel of the Louvre in 2002 as well as Lace Diversions at Galeries Lafayette Haussmann in 2003.

these light-as-a-feather laces, with their abstract, nature-oriented, or schematic designs—for example, Solstiss's lace for Hermès—are produced on enormous machines, where thousands of shuttles swing in unison and carry bobbins so thin that great skill is required to interlace the threads. In fact, experts are called upon.

Threads of all kinds are used: cotton, silk, linen, and polyamide produce the finest laces. But there are also silver and gold threads, which are sometimes made from slender strips of actual gilded metal wrapped around a copper wire core. These types of

thread sparkle like jewelry and are as soft to touch as polished metal. Certain kinds of metallic thread can "remember" shape. That is, because this thread is extremely malleable, it can be sculpted, but it doesn't lose its original flexibility. Solstiss also makes wool, cashmere, and blended-silk laces, which are thick and winter-ready. The warmth results not only from the nature of the fibers, but also from the fact that the holes capture air, which is heated when against skin. Trapped in a threaded cocoon, the warm air blocks against the cold even more effectively due to the holes throughout the fabric.

The process is painstaking. The lacemaker is like a tightrope walker in that he is entirely dependent on a thread that cannot break. Specialists constantly watch over the process, supervising the looms only after many years of training. Literally perched above the machines on a high platform, the tulle workers (always men) oversee all of the loom's movements.

With great agility, they relentlessly and carefully locate the torn thread among the thousands of interlacing and intertwined ones, the bobbin around which it was coiled, and the shuttle from which the bobbin was hanging. If they don't, they lose the whole piece. They also constantly monitor the proper development of the design itself: the tulle worker is able to spot the slightest deviation, even by a few millimeters, barely visible to the layperson's eye. Once he does, he marks it with blue chalk. At the end of the loom, two women—known as *entrées* (visitors) review the lace by passing it between their hands in a rapid, cadenced movement. They find the blue marks as well as other loom errors, which are later repaired by hand.

These details are attended to by other women, who fill spaces that are too large or, conversely, widen holes that are too opaque, thereby rendering the design even. Most lace is manufactured

very wide, between four and six yards, and must be separated into widths. When a circular shape is cropped at the end, the threads are "scaled back" after the width is cut, so that the full roundness is restored. At this time, all loose warp thread on the backside of the lace is removed, which clarifies the design.

All these skills require extensive training, highly developed manual skill, a keen eye, and also—and perhaps especially—a will to make the unique product that is lace. The process is demanding, but the results are gratifying for both the manufacturer and the client.

This basic lace production process is frequently followed by another strengthening and embellishing one that the French call *ennoblissement* (ennoblement). It involves reembroidering the lace, fortifying its spaces with velvet, chenille, or satin ribbon. The contours can then be accented with gold or silver thread, or even with pearls. Feathers and sequins can also be added. In sum, the naked lace that comes out of the machine, which is already beautiful, is upped in splendor.

Computers have also aided manufacturing procedures, especially by replacing the old—although forever efficient—Jacquard system, which uses punched cards to control the thread movement. But the creative process itself isn't compromised by modern technology. The design studio is still the first stop for a new model, and this is undoubtedly where Solstiss has built its reputation, aside from the quality of its production and the finish of its lace. It's not a matter of reproducing popular motifs, even if some designs are classic and in high demand.

Rather, it involves showing that lace can be adapted to all styles and materials while retaining its nature. All motifs, from the most abstract to the most figurative, are immediately transformed by the play of light that the lace openwork affords. Furthermore, its unique character must be preserved. Lace can't be transformed into an ordinary fabric with holes. This is the crux of the work performed by the Solstiss designers, creating motifs and patterns that fit within these standards. The card programmers must then translate the proposed design into mechanical language, using an indispensable and complex color-coded system that takes time to master, even with the help of computers.

Ever since Colbert founded the French royal lace workshop in 1669, the greatest laces have always been French, even if they originally drew on Venetian, Genoese, and Flemish versions. Alençon lace, for example, quickly won the hearts of noblemen and the European aristocracy. And ever since the nineteenth century, machine-made Alençon lace has really been the only lace known in the United States.

In the 1930s, despite the worldwide depression, lace was one of the first French products to be exported. The "boyish" fashions of the time, in fact, were deeply inspiring to designers, and rivaled trends that rendered the feminine silhouette more masculine. The U.S. Congress quickly sent a delegation to Paris, Calais, Caudry, and Lyon to study the possibility of establishing the industry on American soil. It never happened, or it was executed poorly, for there is essentially no lace tradition in the United States, neither handmade nor machine-made (except for a small bobbin lace, also known as bone lace, company in Massachusetts). Lace products are treasured by American high society because they usually bear a French mark. It has always

been the case that the United States and other counties, even European ones, many of which do have a lace tradition (Italy, for one), import lace from France. It is no coincidence that Solstiss exports ninety percent of their lace production to almost seventy countries—including Asia, where lace is cherished, in spite of (or because of) the fact that there was no lace tradition in Asian countries before it was introduced by Europeans at the end of the nineteenth century.

This international success reflects the enduring power of French luxury goods and demonstrates how Solstiss has been able to maintain the standards of taste on which the company's reputation is founded; it has endured since the Louis XIV aesthetic takeover in the seventeenth century, which conquered the world.

Under the direction of Joël Machu, president of Solstiss and the inheritor of an old lace manufacturing company, and under the direction of Roger Ledieu, CEO, who is also from a lace family, approximately 250 people work for the six companies that form Solstiss. They are passionate and always busy. Their work is as fast-paced as fashion itself, because lacemaking is as demanding as its clientele. A loom can not be turned off once it is set in motion. The tension of the threads must be regularly maintained in order for the piece to be unified. Lace, by definition, suffers from any glimpse of mediocrity. The employees at Solstiss have every right to be proud when they see their work on the runways of Paris, New York, and Milan, on the red carpets of cosmopolitan festivals, and in the pictures taken by paparazzi.

Their products are worn by the likes of Nicole Kidman, Madonna, and Isabelle Adjani, women that society has chosen—at least for now—to be among the most beautiful, the most famous, and the most elegant.

PARFUM

Femme

ROCHAS

CHANCE

CHANEL

Chronology

1974: Four established lace manufacturers decide to merge into one company named Solstiss. The goal is to gather together their talent, increase their creativity, and obtain larger and faster means of production. The four establishments include the Maison Ledieu Beauvillain, specializing in twelve-point lace; the établissements Victor Machu and AEG Joël Machu, known for their wide range of colors, the Société Robert Belot, famous for its Chantilly lace, and the Maison Edouard Beauvillain (Edouard Beauvillain and Henri Beauvillain companies), reputed for the diversity and richness of their lace motifs. Because of social upheavals during this time, lace experiences a period of crisis. Bras are thrown out the window, the Vatican no longer requires that a mantilla be worn during mass, miniskirts and the bodies they reveal make the mystery of lace obsolete. At this point, Solstiss steps up to the plate and proves that it can adapt in exemplary fashion. The company survives because of the pragmatism of its work supervisor and the generosity of its personnel. This ferocious will to keep a profession on the brink alive is what saves Solstiss. The trade is modernized, and the company invests in human hands, even more than finances. Other companies give up and sell their wonderful lace looms for scrap.

1981: A showroom opens in Paris.

1985: A Solstiss branch opens in New York on Seventh Avenue in the city's mythical fashion district.

2002: Solstiss's sales are twenty times as high as they are in 1974.
"Lace Body" opens at the Carrousel of the Louvre.

2003: "Lace Diversions" opens at Galeries Lafayette Haussmann.

Dew on a spider web. © *Bill Ross/Corbis.*

2004: Solstiss adopts a new legal and financial structure that corresponds to its needs. The goal of the restructuring is to form a larger financial entity that favors investment, with regard to industrial equipment as well as training and design. It involves simultaneously perpetuating French expertise—now unique in the world—and assuring that innovations are continually made.

2005: Sales progress at a regular rate. Solstiss's client list includes the biggest fashion designers in the world from France, England, Italy, Japan, and the United States, as well as Lebanon, Russia, Turkey, and Israel. Their names bring to mind images of women in lace.

2006: Solstiss owns and runs no less than eighty-five Leaver looms with which to produce its high-end lace products, making the company one of the top houses in the world specializing in lace. Solstiss/Baccarat partnership.

Paris Match cover in the 50's. © *Paris Match.*

PARIS MATCH

N° 299 Du 18 au 25 DÉC. 1954 50 Fr.

AVA GARDNER SAUVÉE PAR LA R.A.F.
L'héroïne de « Mogambo », qui se rendait de Hong Kong à Singapour, a été prise dans une tornade et a fait un atterrissage forcé à la base britannique de Butterworth. Les aviateurs lui ont demandé en souvenir ses souliers, dont ils ont fait la mascotte de l'escadrille.

solstiss

Empress Eugenia Surrounded by Her Maids of Honor, 1855, by Franz Xavier Winterhalter, detail, Château de Compiègne. © Photo RMN.
Corsets displayed in a store window, Boulevard de Strasbourg, Paris, circa 1900. © Eugène Atget/BNF.

Jacquard perforated cards, virtual sheets of music. They are used to produce lace designs. Photo: Michel Brassard. © Solstiss.
Lace being woven. Photo: Michel Brassard. © Solstiss.

In 1911 the latest fashions were launched at the Auteuil races in Paris. Photograph published in *L'illustration*, June 24, 1911. © *L'illustration*.
Actress Audrey Hepburn wears a Gaby Desly lace dress and a feather hat, both designed by Cecil Beaton for the Broadway musical *My Fair Lady*. © Condé Nast Archives/Corbis.

Portrait of Baroness Elisabeth Bachofen-Echt by Gustav Klimt, 1914. © IMAGNO/Austrian Archives.
Chantilly lace motif introduced in February 2001. © Solstiss.

Solstiss lace for Valentino, haute couture fall-winter 2006-2007. © Patrice Stable.
Fashion in the 30's, from left to right: Alden Gray wears a Madame Frances dress, Marion Morehouse wears a Jay-Thorpe dress, Miss Collier wears a lace dress and a straw hat. © Condé Nast Archives/Corbis.

Painstaking mending. The work is invisible. Photo: Michel Brassard. © Solstiss.
Solstiss lace for haute couture Gaultier Paris, fall-winter 2005-2006. © Patrice Stable.

Solstiss lace for Emanuel Ungaro, haute couture line fall-winter 1998-1999. © Regan Cameron/Tony Jay Inc.
Grace Kelly at her wedding to Prince Rainier of Monaco, April 19, 1956. © Bettman/Corbis.

Guipure lace. © Solstiss.
Adidas jogging suit designed specially by Sarah Sumfleth for the exhibition "Détournement de Dentelles." Photo: Myqua. © Solstiss.

Solstiss Chantilly lace: from top to bottom, left to right: Chantilly lace, designed May 17, 1948, designed September 22,1947, designed April 30,1948, classic bouquet of flowers in cotton, designed February 21,1952, designed February 6,1952, Chantilly lace on collar, designed March 14, 1952, classic pattern in cotton. © Solstiss. **Solstiss lace dress for Balmain,** prêt-à-porter line, fall-winter 2006-2007. © Patrice Stable.

Paquin was inspired by Velasquez for this black lace velvet veil. © Horst/Condé Nast Publications, 1937.
Alliance between lace and Persian lamb for this Paquin's dress. © Horst/Condé Nast Publications, 1936.

Golden Chantilly lace by Solstiss. © Solstiss.
Portrait of the legendary actress Gloria Swanson behind a lace veil, 1928. © Edward Steichen/Steichen Carousel.

A sublime Maria Felix in black lace in Julio Bracho's film *Mujer de Todos,* 1946. © Cinateca de Mexico City.
Mystery and elegance. Conversation among masked aristocrats as depicted by Pietro Longhi, 1740. © The Art Archive/Corbis.

Christian Louboutin's famous Alta Mesh boots designed with Solstiss lace, winter 2002-2003. Photo: Myqua © Solstiss.
Christian Lacroix jacket made with Solstiss lace, haute couture fall-winter 2002-2003. © Patrice Stable.

Solstiss lace: from top to bottom, left to right: introduced September 2001, Graphic motif used by Baccarat, designed on March 11, 1952, introduced February 2003, embroidered Chantilly lace, introduced September 2000, spider web lace, Guipure lace, introduced September 2000. © Solstiss.
Mantillas worn by Sicilian women, 1900. © All rights reserved.

Solstiss lace for Lagerfeld Gallery, prêt-à-porter line spring-summer 2002. © Patrice Stable.
Lace jacket over a 1950s evening dress. © Condé Nast Archives/Corbis.

Rochas adopts a lace motif for its legendary "Femme" perfume. © All rights reserved.
Solstiss lace dress for Rochas, worn by Jennifer Connelly. Photo by Nathaniel Goldberg published in Italian *Vogue*, March 2004. © Nathaniel Goldberg/Total Management.

A troubling and sensual Marilyn Monroe in a black negligee, circa 1955-1957. © Tallandier/Rue des Archives.
Dress designed with Solstiss lace, worn by Isabelle Adjani during a rehearsal of *La Dame aux Camélias* at Théâtre Marigny. © Marianne Rosenstiehl/H&K.

Chantilly lace. © Solstiss.
Actress Audrey Hepburn wearing a lace mask. © Bettmann/Corbis.

Solstiss lace for Gaultier Paris, haute couture line spring-summer 2002. © Patrice Stable.

Solstiss black lace as used by the House of Dior for a spectacular dress, haute couture Dior runway show, fall-winter 2005. © Patrice Stable.
Animal motifs are very rare. Solstiss designed this one in 1988. © Solstiss.

Little black dress made with Solstiss lace for Chanel. Flounced version for the Chanel collection, prêt-à-porter line, fall-winter 2003-2004. © Photo: Karl Lagerfeld/Chanel.

Dionysos carafe by Baccarat. Lace-crystal concept by the architect/designer Reda Amalou. © Baccarat.
Mesh lace. © Solstiss.

Tunic with Tunisian collar made with dark red Solstiss lace for Hermès with golden yellow silk taffeta bras and a golden yellow silk taffeta shorts in Hermès canvas, spring-summer 2006. Photo: © Patrice Stable.

Solstiss lace made exclusively for Louis Vuitton, 2003. © Louis Vuitton.
Louis Vuitton runway show, prêt-à-porter line, spring-summer, 2004, Bronze taffeta trimmed with Monogram guipure lace by Solstiss for Louis Vuitton, ecru silk shorts, suede strap sandals. © Frédérique Dumoulin.

Solstiss lace dress for Elie Saab Couture, spring-summer 2006. © Patrice Stable.
Dress with black Solstiss lace for Dolce & Gabbana, haute couture line, spring-summer 2004. © Patrice Stable.

Solstiss lace for Dolce & Gabbana, spring-summer 2004. © Patrice Stable.
Black and red guipure. © Solstiss.

Anna Vialitsyna, the woman behind the perfume Chance, in a spidery Chanel dress with Solstiss lace, photographed by Jean-Paul Goude, 2003. © Photo: Jean-Paul Goude/Chanel.
Drawing by Karl Lagerfeld for the exhibition "Détournement de Dentelles", Solstiss 2002. © Galuchat.

All these years of lace would not exist without those who worked, directly and indirectly, to produce the precious yards in its different and vital stages.

But, before all else, a special homage must be paid to Mr. Reverse, the employment supervisor in Cambrai between 1960 and 1970, who allowed us to manage our employees with remarkable flexibility. As a result, he is one of the first Solstiss artisans we have come to know.
Next, we thank all those involved in the loom work:
The design team: the draftsmen, the card programmers, stipplers, fine bar markers, card punchers. The preparation team: the wheelers, wrappers, warp workers, winders, pressers, regulators, ranoueurs. The production team: the foreman, loom supervisors, tulle workers. The finishings team: the reviewers, menders, folders, hemmers, trimmers, samplers. The administrative personnel, sales marketers, business assistants, packagers, researchers, and developers. All of these colleagues, throughout the years, have played a fundamental role in the success and development of our business.

Thanks also to Agence Galuchat, Nathalie Elmaleh, and Laurent Teboul.

The author would like to thank Mr. Machu and Mr. Ledieu for welcoming us into their businesses in Caudry, as well as Marie-Catherine Santerre at the Paris Solstiss showroom.
Thanks also to Géraldine Salley from *Mode* in Press.

The publishers wish to thank Erin O'Connor, Jennifer Connelly, Natasha Polly, Julia Schonberg, Morgane Dubled, Anna Vyalitsyna, Leticia, Jessica Stam, Luca Gadjus, Tetyana Brazhnyk; Irina Lishova, Carmen Kaas, Snejana Onopka, Isabelle Adjani, Chantal Fagnou and Donat Barrault (Viva Models), Cari Ross, Elisabeth d'Agostino (IMG World), Bruno Jamagne (Women Management), Patrick (Marilyn Agency), Pascale et Patrick (City Models), Eric Dubois (Silent Models), Ali (One Model Management, Patrice Stable. Laurence Kersuzan and Pierrick Jan (RMN), Anne-Céline Fuchs *(L'Illustration)*, Isabelle Martin and Fabienne Delfour (Corbis), Myqua, Laurie Platt Winfrey (Steichen Carousel), Bronwen (Total Management), Risa Shapiro (International Creative Management), Raymond Meier, Catherine Terk (Rue-des-Archives), Hervé and Philippe (H&K agency), Leigh Montville and Claire Fortune (Condé Nast Permissions Department), Ali (Tony Jay, Inc.), Marika Genty (Chanel), Katharina Bacher (Imagno), Frédérique Dumoulin, Chantal Fagnou (Viva Models).

Solstiss thanks all the designers and stylists who participated in this book and those who are not included but who continue to feed our dreams with their work.
Thanks also to all the models who appear in this book.